The Anti-Racism Activity Book

Activity Book

**Written and Illustrated by
Victor Varnado**

**Dedicated in loving memory to all the racists that
won't exist after reading this book.**

**Or perhaps you believe racism already doesn't exist,
in which case this might be a great book for you.**

Beep Boop Books
442 Lorimer Street
Brooklyn, NY 11206
www.BeepBoopBooks.com

Ordering Information:
For details, contact info@beepboopbooks.com.

ISBN: 978-1-387-45856-1

First Edition

To my patient and loving Kickstarter backers:

Thank you! I wish it didn't take so long and I appreciate your support. Everyone else, take note, these people were into The Anti-Racism Activity Book even before anti-racism was cool.

Brian Christopher • The Creative Fund By Backerkit • Rachel Franzen • Snowrunner Games • Keith Garde • Philip Gelatt Corey Burrington • Michael Bernard • Cyrus • Jennifer Glick Carly Ott • Jason Mrwonderful Deitcher Mxse
Lindsay Crawford • Beth Ocar • Elena Ordille • Rikki Popsun Clara Gelatt • Travis Charles Ploeger • Elektra Diakolambrianou Smoothiefreak • John Elrod Ii • Chris Van Waus • Kristine Clancy Mudit Verma • Mira Fahrenheit • Helena Hamilton • Athena Clayton Danielle Love • Cassie • Peachie Wimbush-Polk • Ashley Beudeker Stephen A. Edwards • Robyn Chapman • Joseph Herrera
Lori Constable • Jay Stern • Abby Scott • Christian Finnegan Octavia Butler • Amanda • David Miner • Rob Paravonian Nancy Kito • Kristen Romanelli • Claudia Hankin Balluff Mary Evans •Nowal Jaber Jamhour • Emily • Shafi Ziauddin Van Scott • Damien Lewis Shediak • Erin Chan • Tim Maxwell Noam Osband • Corinne Gutstadt • Ruth Cassidy • Elizabeth Meggs Jason Curry •Austin Basis • Sayume Romero • Craig Hatkoff Pete Westwood • Paul Sampson • James Rhee • Jesse
Ashley Juvonen • Robyn James • Karen Sneider • Mhempton Cece • Jessica Tucker • Karyn Luger • Nicole Damour • Sarah Ritch Duncan • Jason Kanter • Tracy Sagalow • Eric Kunkel Kimberly Gatewood • Joan Estep • Backerkit • Lafia Morrow Larry R • Myq Kaplan • Todd Levin • Claire Kelly • Jim Manchester Skippy • Mary Wais • Polina Roytman • Eva Gilliam • Jeni Zortman Lesley Ware • Sofía Warren • Eric Drysdale • Mike A Simms Egan Sweeney • Lynne • Cynthia V • Lori Malvey • Staci Eddy Lillian White • Carolyn E Lewis • Delance Minefee
Rachel Teichman • Leigh-Anne Weiss • Susan Felber • Khanh Duy Russo • Tia Schellstede • Darryl Charles • Sue • Erin • Jeff Miller Amberlee Mucha • Ellen Ruth • Lena • Karl Brophey • Pamela Wess Travis Arenas • Becky Laford • Wendi Starling • Yamah
Evelyn Curtis • Beth Borschiov • Joshua Murphy • Shawn Alexander Allen • Marc Francisque • Paula Dixon • Lisa Flanagan
Robin Spanier • Eric Knobel • Gavin Greene

3

ABOUT THE AUTHOR

Hi!

My name is Victor.

As a black person born with albinism I have been around white people when they didn't know someone Black was around.

I have also been around Black people who mistook me for white.

As you can imagine, I've seen some... stuff.

Circle the people who guessed my race wrong on the next page

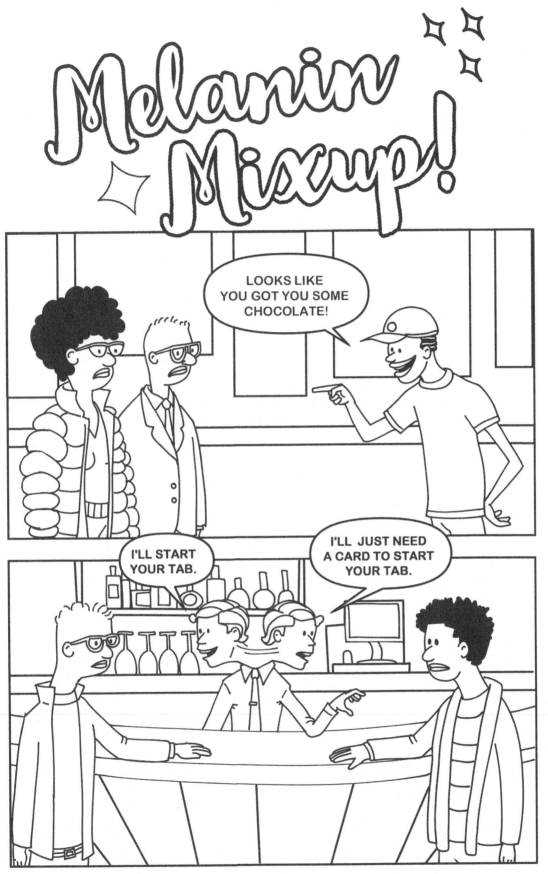

Circle the confused culprit in each of these true stories.

Thank you for buying this book. In exchange, I hereby absolve you of all of your previous racist transgressions.

CERTIFICATE OF ABSOLUTION

Presented to

(YOUR NAME HERE)

By buying this book you have been absolved of any past racism.

On this _____ Day of _____ in the Year _____

THIS CERTIFICATE NOT VALID UNLESS SIGNED BY AT LEAST TWO OF YOUR BLACK FRIENDS.

RACISM IS BAD

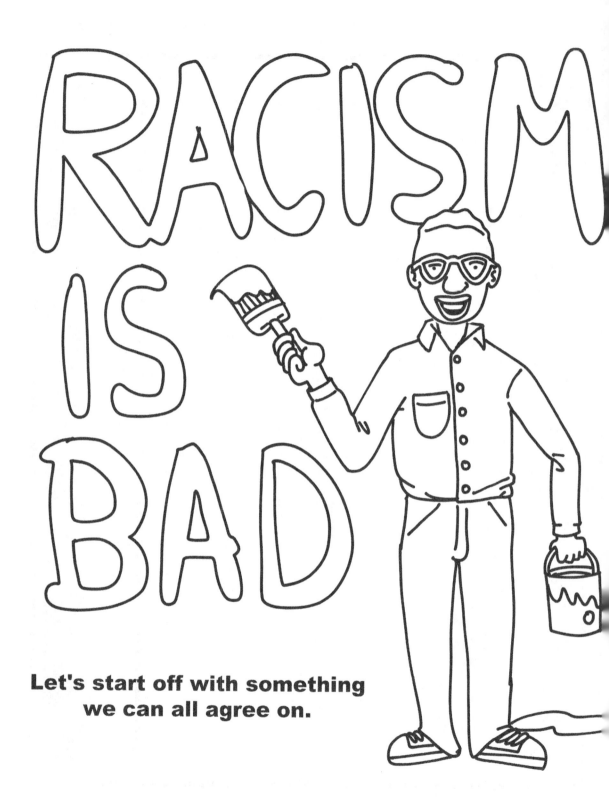

Let's start off with something we can all agree on.

Or maybe I'm wrong? can you decipher what these two are whispering about?

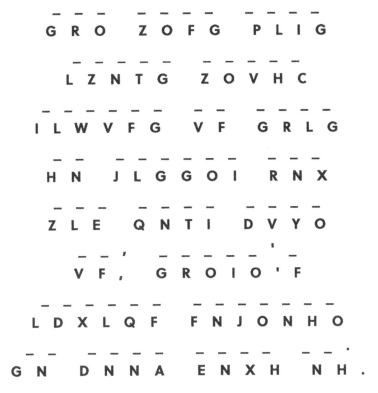

```
_ _ _   _ _ _ _   _ _ _ _
G R O   Z O F G   P L I G

_ _ _ _ _   _ _ _ _ _
L Z N T G   Z O V H C

_ _ _ _ _ _   _ _   _ _ _ _
I L W V F G   V F   G R L G

_ _   _ _ _ _ _ _   _ _ _
H N   J L G G O I   R N X

_ _ _   _ _ _ _   _ _ _ _
Z L E   Q N T I   D V Y O

_ _ ,   _ _ _ _ _ ' _
V F ,   G R O I O ' F

_ _ _ _ _ _   _ _ _ _ _ _ _
L D X L Q F   F N J O N H O

_ _   _ _ _ _   _ _ _ _   _ _ .
G N   D N N A   E N X H   N H .
```

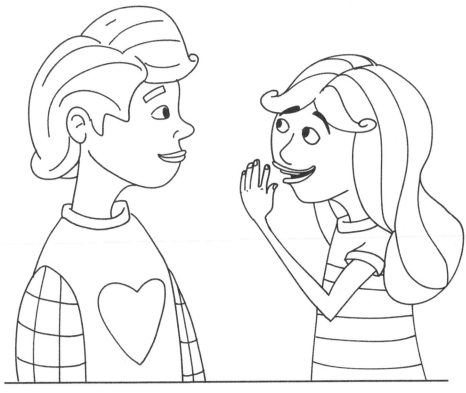

They kinda have a point.

EVERYONE COUNTS!

Number these races from best to worst.*

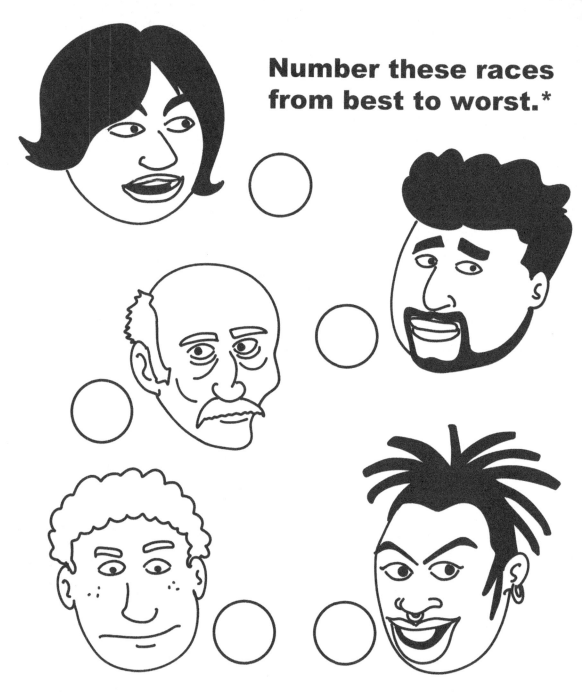

"And remember, these are all questions you should be asking yourselves."

WHITEST JOBS

The Atlantic made a list of jobs that Black people almost never have.

```
L J R H W I T V F V C X N A Z E C E P C
H F C W L U Q G N R O R H H C W L F P A
S S M H C T K N M Q T R B Q B P Z B R R
E I T C F H S S A V X E U K S B S D I P
S L R E I U I H V O M Z P R G R M W V E
H X E T E D R R A R C H I T E C T C A N
Q W B C S L B Q O J V Q H D X Z X H T T
X E P T T A W U C P I Q B A C C Y I E E
M K A W K R I O V X R S R I A A B E D R
I D R H P I I T R L J A N Z C E K F E S
L Y A F H B X C U K Z D C Q H V C E T G
L A M V O P S J I L E G K T V I A X E O
W F E V I O W U G A I R U P O N P E C Y
R A D E V E L D M U N M A R Z R N C T A
I M I V J X M I R Q K C T Z C U K U I W
G G C O E K Y J K J N V A F M H J T V V
H P T E K V E T E R I N A R I A N I E F
T D W I H R A S N R F P F N N U G V I O
A U T O B O D Y R E P A I R W N N E J U
N G C I V B C A I R C R A F T P I L O T
```

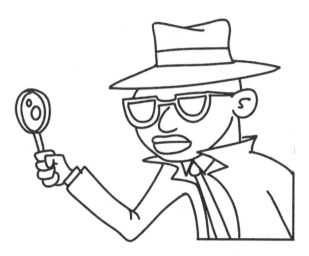

ELECTRICIAN
PRIVATE DETECTIVE
CHIEF EXECUTIVE
AUTO BODY REPAIR
CARPENTERS
ARCHITECT
CHIROPRACTOR
PARAMEDIC
STEEL WORKER
AIRCRAFT PILOT
MILLWRIGHT
VETERINARIAN

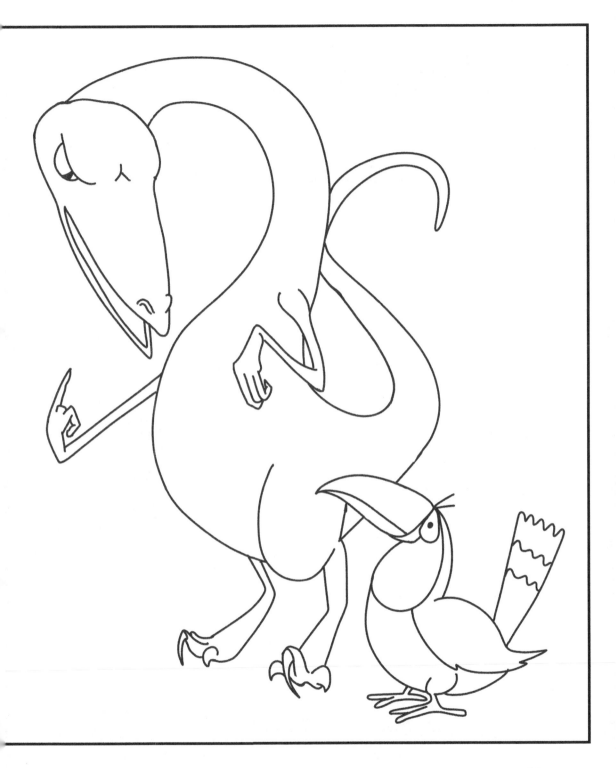

"It's okay. I can say that; I'm part bird."

EXECUTIVE AMERICANS

Can you name all the Black U.S. presidents and vice-presidents?

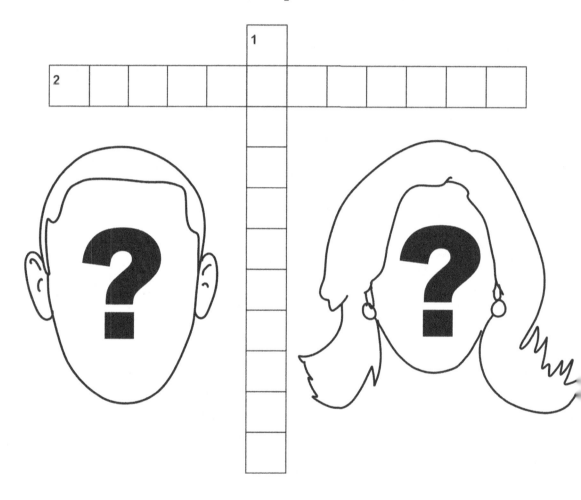

Down
1. Michelle's husband

Across
2. Take a wild guess

"It's expensive but it was made by a minority owned business and who can put a price on guilt?"

"Politics would be funny if it had no effect on our lives."

a-MAZE-ing RESPONSE

Help me navigate the negative
internet comments this book
will generate.

"I have envied that your hair is easier to manage."

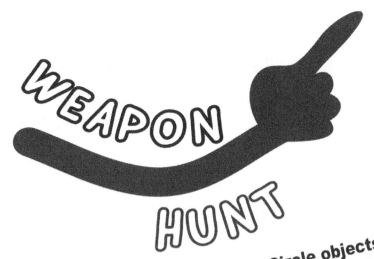

WEAPON HUNT

Circle objects that the police have mistaken for a gun in the hands of Black people.*

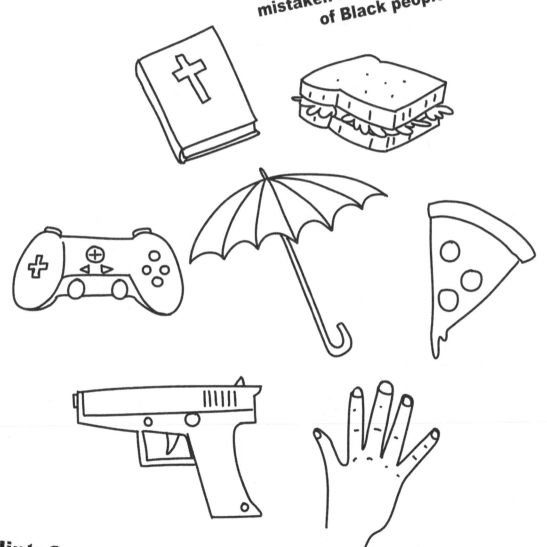

***Hint: Sometimes it was just a hand.**

CONNECT THE DOTS
Help draw the target on Eric's back.

HISTORY LESSON

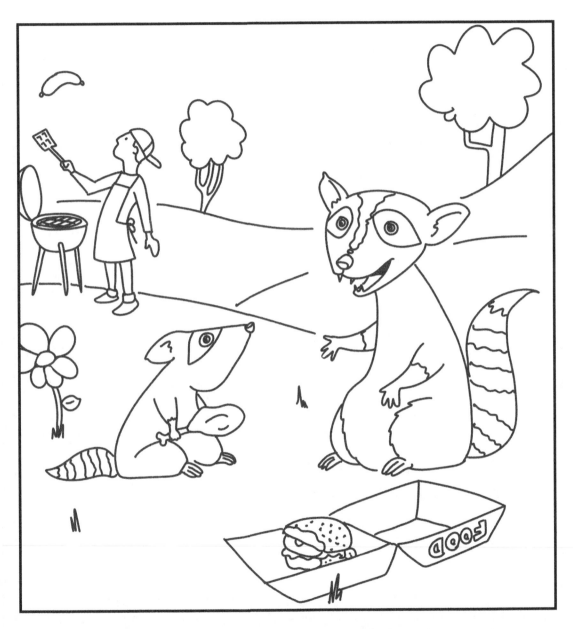

"Juneteenth is not just the day Santa delivers extra barbecue scraps to parks around America."

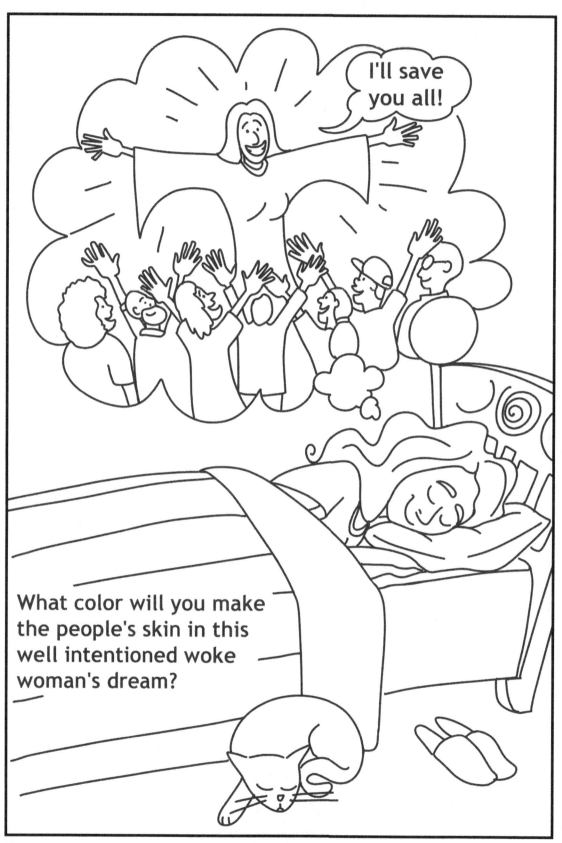

THIS PAGE HAS
All the white people that need to say the
N - WORD*

* **If you disagree feel free to draw yourself in.**

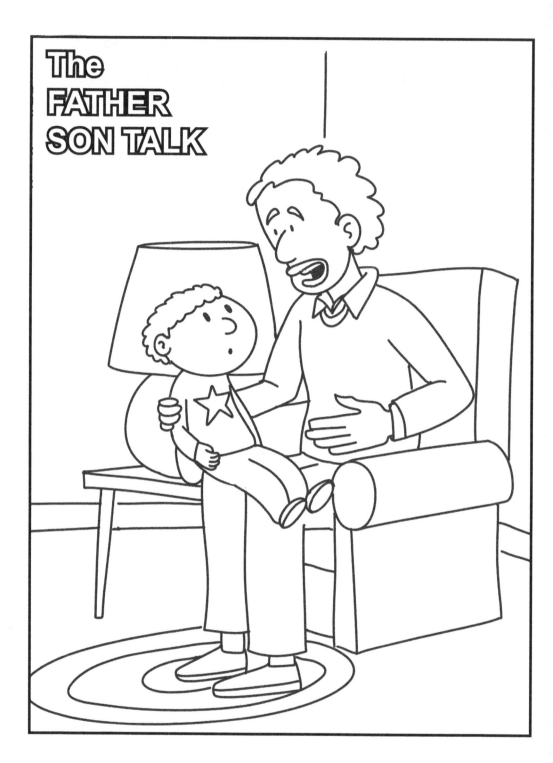

"There's penises and vaginas sure, but most importantly learn to duck."

NAME THE RACIST MASCOTS

Across
3. First she was a banana but now she just wears them
4. At least Fritos only used this guy for four years
5. The most popular pancake mix that ever used a
 Black human being as a mascot
7. It only took one hundred and eight years for this
 butter to stop using an Indigenous American woman
 on her knees on their packaging
8. Pour the sweetness out of this tiny
 Black woman's head

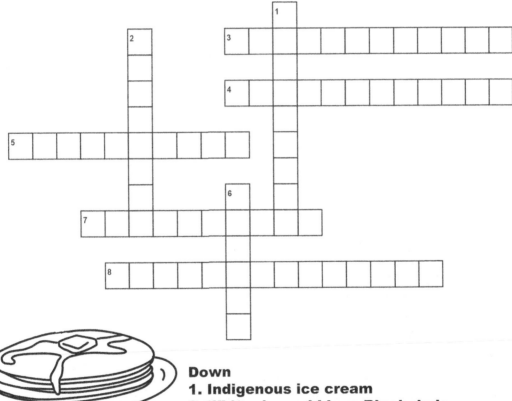

Down
1. Indigenous ice cream
2. White rice sold by a Black dude
6. What's that guy's name on the Cream
 of Wheat box?

RESU-MAYBE NOT

ABC News published a list of the 20 Blackest sounding male first names.

```
I H S A G Y O N T T E R R A N C E J C H
W U Z W J D G H A V L R Q S G J D S A M
X K M E C Q N O E R M N E C C L O X H I
Q X U P I Q F Q B X D Y Q G E K O V Z D
X D A R N E L L B G T K O U I D C S T A
W A D E M E T R I U S U D E A N D R E R
H N M G U C N M I S P D L G W X A I W R
T D A I T G R W S G T D N B V J Q L H Y
M R R D P D O D E S H A W N T A X Z D L
R E Q X O I A Z T P R V A E W M V Q G O
G E U C A M A R O P I Y S X A A T D H L
T H I C S A I X I U L Z X J A L E N W B
I M S Q X U D N X U P E R R S T P Y M N
V V B M A X S T I V S J W W B T G D A O
Z K W A V X R F I Q G S Q I P I X M U K
C B V L I L G X D O U G B N L C W I R K
X I N I E G X O L F D E E K W L L Q I T
V S O K R P X Z M T Y R O N E U I A C Y
V B C T R E V O N D G H X G M J M E E E
T L R G Q B G F V G N L Q T E R R E L L
```

Help Alan find them so he can reject their resumes prematurely.

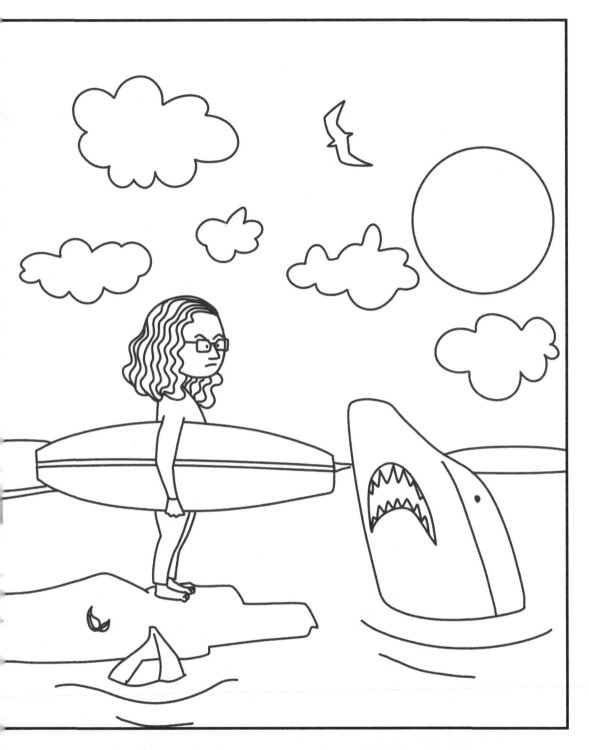

"Oh, you think just cause I'm a shark I'm going to eat you? That's predjudice. Get in the water or you're canceled."

Animal Crossing

Match the Black lead in an animated movie to the animal they were turned into during the film.

"I couldn't help but constantly notice that you're Black."

**"Congratulations. You're our
diversity hire."**

STOP RIGHT THERE!

Can you find all the things people have called the police on Black people for?

Down

1. Bringing newspapers to people as detailed in their job description
3. Selling bottled _____
5. Catching some Z's between classes in their college dorm
6. A woman called the police on departing AirBNB guests because they did not wave or smile at her
7. Sitting in Starbucks a few minutes before their friends arrived
9. Five women played _____ too slow in Pennsylvania which TEE'd off the owner of the course.
10. Asking for _____ because they were lost - I guess it's too bad they asked the same person who called the cops on someone for sleeping in the dorm. I can't believe this is true. Well I can.
11. While standing outside his own _____ store a man had a SOUR experience which bore no FRUIT for the police
14. Eating a midday meal on a college campus
15. Brushing up against a woman while their _____ is filled with school supplies

Across

2. Cooking meat on a grill
4. Carrying furniture into their new apartment
8. While riding in a car with his white grandmother
12. Lifting weights at a gym they were a member of
13. They were doing home inspections so were in uniform but without their HOSE or AXE
16. Looking after two white children while their parents were away
17. After a week of work they went to a bank and were asked to show two forms of ID and give a fingerprint but the teller still refused to cash the _____ and also called the police
18. Looking for prom clothes at Nordstrom Rack

31

A rebus we can all agree with.

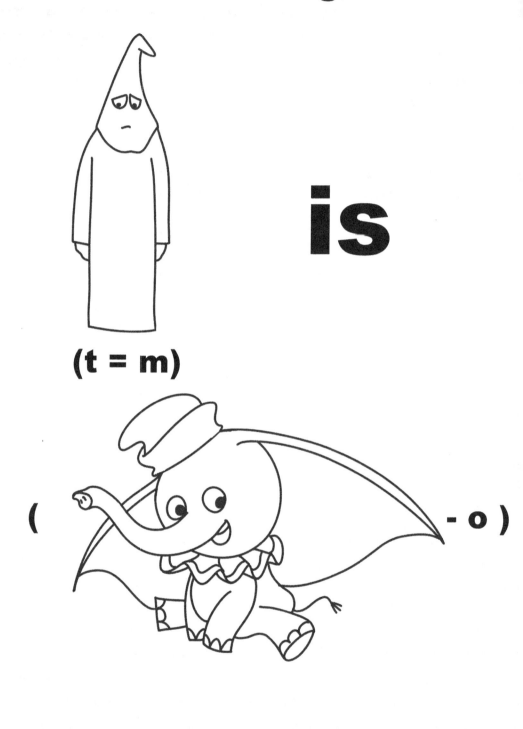

(t = m)

is

(‑ o)

_____ __ ____

RACIST WORDS AND PHRASES

**Not saying you can't say them,
just that you should know what you're saying.**

```
Q H X O R K Q Q C H C J W H M V W E K K
V Z T Z X M A S T E R B E D R O O M V Z
B C S O I E O F F A C U Y V P X T T V Z
M R P P Q E U P K Y F J T X T N E W J T
U F L G A X E B E R M U P P I T Y G Y J
M R A R E K E S Z N J U G W W E V T H P
B E N D I P E A N U T G A L L E R Y G N
O E T H A R O N U K K H C I E S K I M O
J H A C X I V V U Q U R E A A J Q Z S T
U O T S P W T R Q E A E G K K O A D J G
M L I F F U Z Z Y W U Z Z Y I E A C H S
B D O W X H E P G Z Y X K Z H M W V K B
O E N R F Q X X K N Z I A U E M O A G L
M R C M K S X C Z L W C V H W C W N L R
I N D I A N S T Y L E A D Y D J V O O K
G O F F T H E R E S E R V A T I O N E F
Y K Y Q P R V N Z K C N F V M U C P N R
P C C G F R I S Z P Y J L U L D J G X V
D N T O F Y G P A D D Y W A G O N J J X
A A B J I M M I E S I X H T D D B X Y X
```

OPEN THE KIMONO	INDIAN STYLE
FUZZY WUZZY	MUMBO JUMBO
PLANTATION	UPPITY
OFF THE RESERVATION	GYP
ESKIMO	FREEHOLDER
PADDY WAGON	JIMMIES
PEANUT GALLERY	MASTER BEDROOM
	CAKEWALK

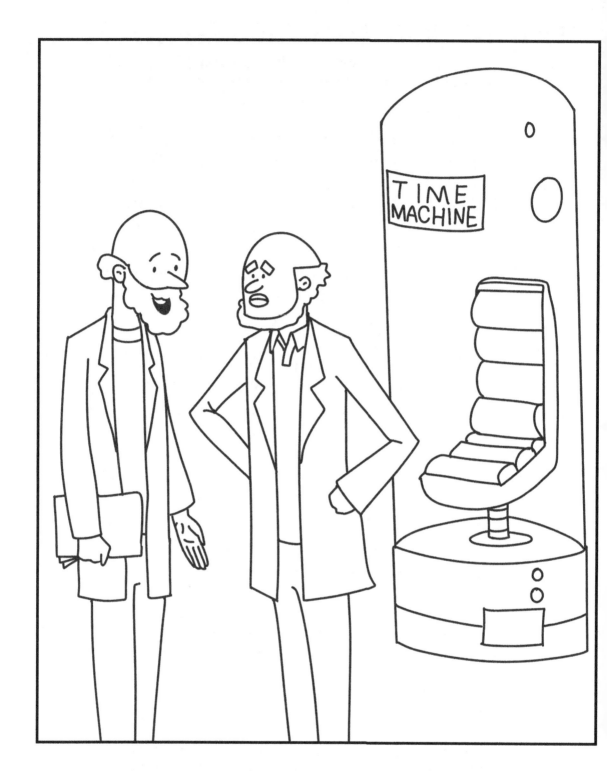

**"Why don't you want to travel
to the past?"**

COINCIDENCE?

```
_ s   _ _ _ r _ _   _ r _ _ _ _   _ h _
D n   Y z o m j d o   m v i f z y   o c z

"_ _ _ _ _ s _ _"   _ _ _ _   _ _   _ h _
"w g v x f z n o"   x d o t   d i   o c z

_ _ _ _ _   S _ _ _ _ _ s   _ _ _ _ _ S _
P i d o z y   N o v o z n   w z x v p n z

_ _ ' s   _ _ s _   _ r _ _ _ _   _ h _
d o ' n   v g n j   m v i f z y   o c z

_ _ S _ _   _ _ _ _ _ r _ _ _   _ _ _ y _
h j n o   y v i b z m j p n   x d o t

_ r   _ s _   _ _   _ h _   _ _ _ _ r _
j m   d n   d o   o c z   j o c z m

_ _ y _   _ r _ _ _ _ _ ?
r v t   v m j p i y ?
```

"Your son has albinism, which is a condition where everyone will think you're his nanny."

INVENTIONS BY BLACK WOMEN

Have fun with your Google searches.

HAIRBRUSH
HOME SECURITY SYSTEM
CURLING IRON
IRONING BOARD
CENTRAL HEATING
VOICE OVER INTERNET PROTOCOL
PASTRY FORK
FRUIT PRESS
CATARACT TREATMENT
ILLUSION TRANSMITTER

```
I S H P V I V X S L W S P X E D Z F C B U Y U W H H C L G R
X C C A J S O C S D S J G P D O E Z K U T J U A R K E O S N
E T G K I C L I P X X S R M V S S Z G B B O K F Z V N H L T
K M T R T R M H V K S Y Y Q Y N R U P M V U F O O Q T H P X
S S Q O M Y B M Q J H N W O G C A M P A S T R Y F O R K H N
G V H D I S P R T Z D M Y F C P B Z Z E X L Q P K J A O G L
R D B W L T I U U M B W H P Q Q C J C L M I P H Z T L W S P
U X Y N Y G V J F S D R X V X G L I I J P W Q D M C H N H T
C U S B T A Q G V C H Z N W F X M H T H N F H H Y B E C P G
X Q K G V U W C O T D I Z K T W O A J L D M K Y V L A T B T
V V V Z L J A N O C C R F U P P M M D W K I E S B O T R K D
E V E A J T W E S P P J N C Y A Z F Z R J L V T P D I J S U
E F Y Z M R J I L L U S I O N T R A N S M I T T E R N G Q X
F N Y H J M G K G C A T A R A C T T R E A T M E N T G D B Q
L I A S H J K P N B W R V X H N A Z P V W T U W J H V O P V
A O P A N O C Y F Z W M E Z S O T V P Q E H E G S W Z B F E
N X F N K E T S Z L R I C H A M A K N F D Q D X J A Y C L D
S D U X R Q Q E W V K V C R V W D N A R Q A V S C H P G Y U
J C U G Y K A I N D X O X D Y Z P L T C N T O H A S A I V H
E P O F S N Y U V D O A Z F J W N N I D P U F M G F V T D T
Z M Q G Q K I B Q F S E C O R G Q X I C Q Y F R G Y M V G M
P V O I C E O V E R I N T E R N E T P R O T O C O L Y I A T
S B I J E B R M G U X B A N L Q R K X V B I M X W B N B S C
O Q V D O Z Y C X I U C I I M Y K F D W C X N N R X W W U B
O N U R L O O W Q T K C U R L I N G I R O N K Y Q V A X D N
F Z B S X H P N W P F W B F S L B E I R O N I N G B O A R D
O G Y Q K G Y M R R W U G L B E T V W U D S G U C K W O W R
T W R E H O M E S E C U R I T Y S Y S T E M T T V P R E D F
S N Q V Z F O I G S K H B R J Z P N Z O G J Q X P U Y J H T
Y A D E N C B E Z S T T N D D S K Y U M U F L H T L P S B Z
```

"Would you mind filling out this psychiatric evaluation before I step out of the car?"

"Do you have any idea how offensive that costume is?"

FINISH THE DRAWING

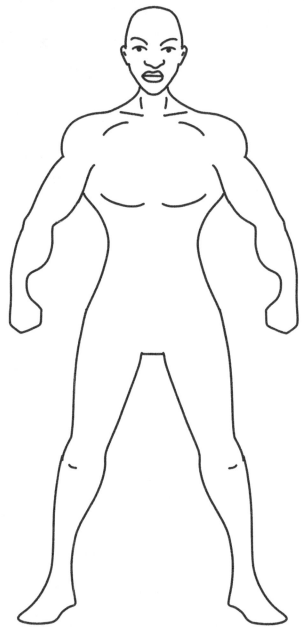

**Make a costume for your own Black superhero.
No electrical, voodoo, or jungle powers. And no
"from the ghetto" or "spirit of Africa" and
you may have something unique.**

CONNECT THE DOTS

Garret Morgam invented a device that makes people of all races angry every day.

I didn't know this before I started researching this book so I thought I would share.

Before "Lift Every Voice and Sing" became The Black National Anthem it was first performed at a birthday party for Abraham Lincoln.

FINISH THE DRAWING

**Draw a hairstyle that doesn't make
white people uncomfortable.**

"Back in the early twenty-first century there was this thing called racism. It was just like the racism of today."

A rebus never lies.

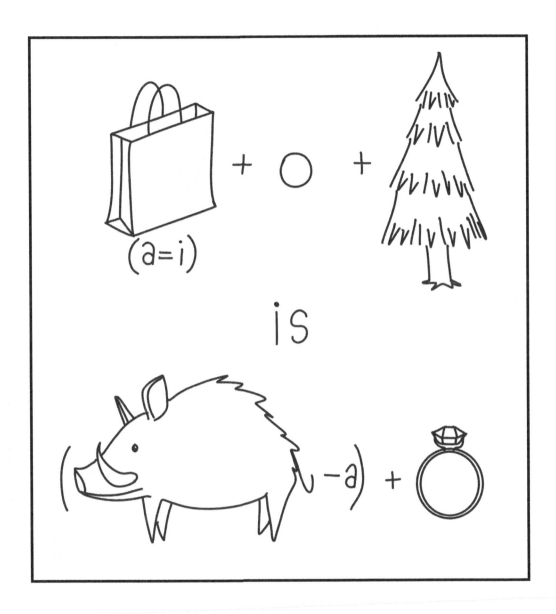

_____ __

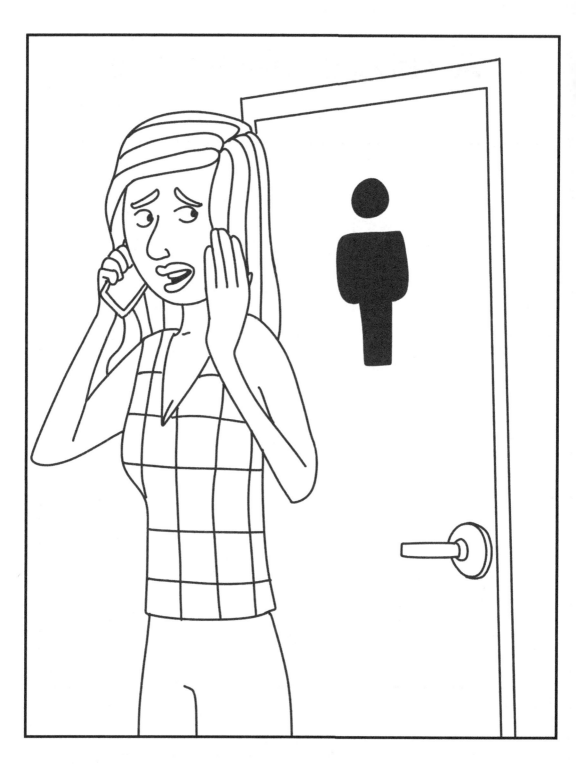

"Hello 911? There's a Black man lingering near the bathroom."

HAIRY CONVERSATION

Help Geneva escape the conversation before Stacy tries to touch her hair.

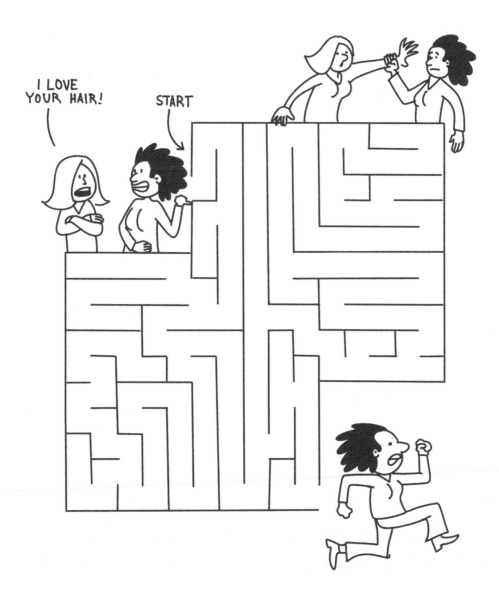

"I hope you're ready for some shortsighted and unsolicited advice."

CALM ACROSS CALM DOWN

Guess what some Black people feel they need to do in order to be less scary to white people.

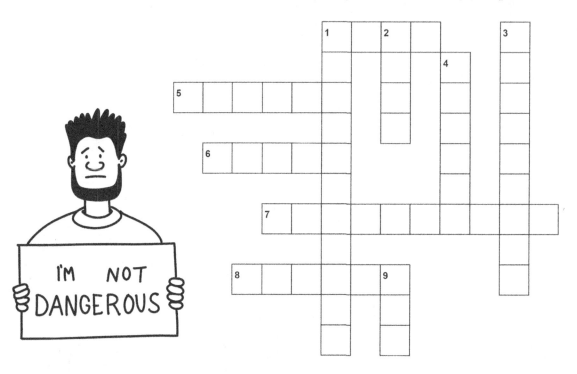

Across
1. When out jogging do this instead of jogging
5. Wear an _____ t-shirt so people know you are educated and certainly no danger at all
6. Don't frown
7. _____ your hair so it looks like theirs
8. Wear _____ because people won't think you'll beat them if your face is beat

Down
1. Travel with a _____ _____ so people know you're safe since you're already vetted
2. Keep quiet and don't be _____
3. Limit the range of emotions you show to _____
4. Don't stand up straight especially if you're gigantic
9. If you are in a public place try listening to _____ music so they know you're docile

NOT SO SECRET MESSAGE

 _ e _ _ _ _ _ _ m e _ _
X f l o p x t p n f p g

 y _ _ _ _ e t _ y _ _ _
z p v b s f u s z j o h .

 _ e _ _ _ _ _ e _ _ _ t e _ t
X f b q q s f d j b u f j u .

CONNECT THE DOTS

**While researching this book
I found out a Black man named
George Crumb invented what I thought
was a white food.**

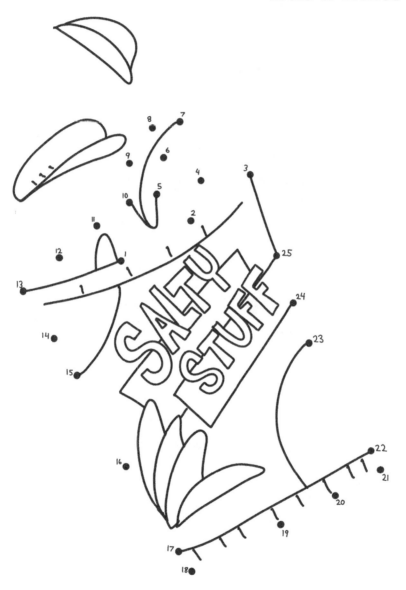

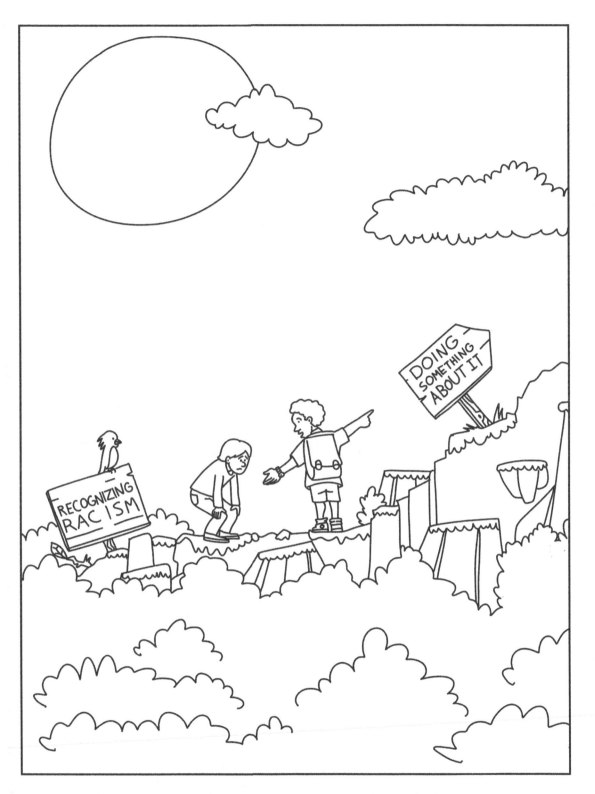

"Actually, we're just getting started."

But at least we have big penises.

ANSWERS

Melanin Mixup!

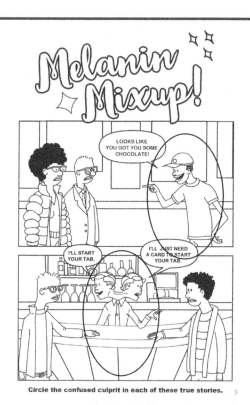

> LOOKS LIKE YOU GOT YOU SOME CHOCOLATE!

> I'LL START YOUR TAB.

> I'LL JUST NEED A CARD TO START YOUR TAB.

Circle the confused culprit in each of these true stories. 5

Or maybe I'm wrong? can you decipher what these two are whispering about?

```
THE   BEST   PART
GRO   ZOFG   PLIG
ABOUT   BEING
LZNTG   ZOVHC
RACIST   IS   THAT
ILWVFG   VF   GRLG
NO   MATTER   HOW
HN   JLGGOI   RNX
BAD   YOUR   LIFE
ZLE   QNTI   DVYO
IS,   THERE'S
VF,   GROIO'F
ALWAYS   SOMEONE
LDXLQF   FNJONHO
TO   LOOK   DOWN   ON.
GN   DNNA   ENXH   NH.
```

They kinda have a point. 9

EVERYONE COUNTS!

Number these races from best to worst.*

INCONCLUSIVE

10

WHITEST JOBS
The Atlantic made a list of jobs that Black people almost never have.

```
L J R H W I T V F V C X N A Z E C E P C
H F C W L U Q G N R O R H H C W L F P A
S S M H C T K N M Q T R B Q B P Z B R R
E I T C F H S S A V X E U K S B S D I P
S L R E U I H V O M Z P R G R M W V E E
H X E T E D R R A R C H I T E C T C A N
Q W B C S L B G O J V Q H D X Z X H I T
X E P T T A W U C P I Q B A C C Y I E E
M K A W K R O V X R S R I A A B E F R R
I L D H P I T R I J A N Z C E K F E S
L L Y A F H B X C U K Z D C Q H V C T E
W F E A M V O P S J L E G K T V I A E O
R A D E V E L D M U N M A R Z R N C T Y
I M I C V J X M I R Q K C T Z C U K U A
G G C O E K Y J K J N V A F M H J T V W
H P T E K I V E T E R I N A R I A N I E V
T D W I H R A S N R F P N N U G V I O
A U T O B O D Y R E P A I R W N N E J U
N G C I V B C A I R C R A F T P I L O T
```

ELECTRICIAN
PRIVATE DETECTIVE
CHIEF EXECUTIVE
AUTO BODY REPAIR
CARPENTERS
ARCHITECT
CHIROPRACTOR
PARAMEDIC
STEEL WORKER
AIRCRAFT PILOT
MILLWRIGHT
VETERINARIAN

EXECUTIVE AMERICANS

Can you name all the Black U.S. presidents and vice-presidents?

Down
1. Michelle's husband

Across
2. Take a wild guess

a-MAZE-ing RESPONSE

Help me navigate the negative internet comments this book will generate.

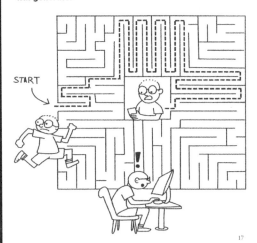

START

WEAPON HUNT

Circle objects that the police have mistaken for a gun in the hands of Black people.*

*Hint: Sometimes it was just a hand.

CONNECT THE DOTS
Help draw the target on Eric's back.

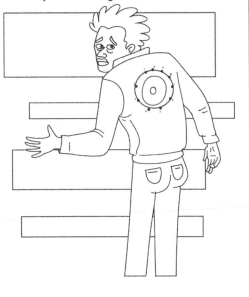

14

17

19

20

NAME THE RACIST MASCOTS

Across
3. First she was a banana but now she just wears them
4. At least Fritos only used this guy for four years
5. The most popular pancake mix that ever used a Black human being as a mascot
7. It only took one hundred and eight years for this butter to stop using an Indigenous American woman on her knees on their packaging
8. Pour the sweetness out of this tiny Black woman's head

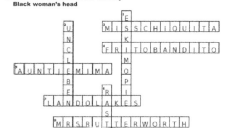

Down
1. Indigenous ice cream
2. White rice sold by a Black dude
6. What's that guy's name on the Cream of Wheat box?

25

ABC news published a list of the top 20 blackest sounding male first names.

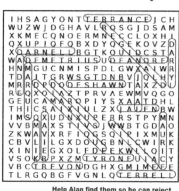

Help Alan find them so he can reject their resumes prematurely.

26

Animal Crossing

Match the black lead in an animated movie to the animal they were turned into during the film.

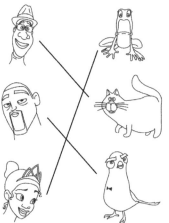

28

STOP RIGHT THERE!

Can you find all the things people have called the police on Black people for?

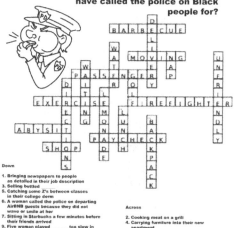

Down
1. Bringing newspapers to people as detailed in their job description
3. Selling bottled
5. Catching some Z's between classes in their college dorm
6. A woman called the police on departing AirBNB guests because they did not wave or smile at her
7. Sitting in Starbucks a few minutes before their friends arrived
9. Five women played _____ too slow in Pennsylvania which TEE'd off the owner of the course.
10. Asking for _____ because they were lost - I guess it's too bad they asked the same person who called the cops on someone for sleeping in the dorm. I can't believe this is true. Well I can.
11. While standing outside his own _____ store a man had a SOUR experience which bore no FRUIT for the police
14. Eating a midday meal on a college campus
15. Brushing up against a woman while their _____ is filled with school supplies

Across
2. Cooking meat on a grill
4. Carrying furniture into their new apartment
8. While riding in a car with his white grandmother
12. Lifting weights at a gym they were a member of
13. They were doing home inspections so were in uniform but without their HOSE or AXE
16. Looking after two white children while their parents were away
17. After a week of work they went to a bank and were asked to show two forms of ID and give a fingerprint but the teller still refused to cash the _____ and also called the police
18. Looking for prom clothes at Nordstrom rack

31

58

A rebus we can all agree with.

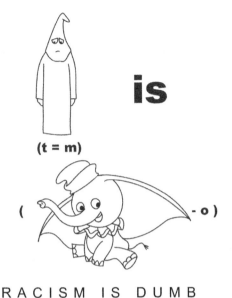

is

(t = m)

(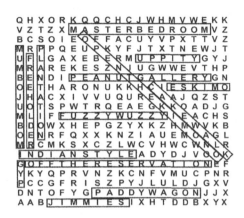 - o)

R A C I S M I S D U M B

32

RACIST WORDS AND PHRASES

Not saying you can't say them,
just that you should know what you're saying.

```
Q H X O R K Q Q C H C J W H M V W E K K
V Z T Z X M A S T E R B E D R O O M V Z
B C S O I E O F F A C U Y V P X T T V Z
M R P P Q E U P K Y F J T X T N E W J T
U F L G A X E B E R M U P P I T Y G Y J
M R A R E K E S Z N U G W W E V T H P
B E N D I P E A N U T G A L L E R Y G N
O E T H A R O N U K K H C I E S K I M O
J H A C X I V V U Q U R E A A J Q Z S T
U O T S P W T R Q E A E G K K Q A D J G
M L I F F U Z Z Y W U Z Z Y I E A C H S
B D O W X H E P G Z Y X K Z H M W V K B
O E N R F Q X X K N Z I A U E M O A G L
M R C M K S X C Z L W C V H W C W N L R
I N D I A N S T Y L E A D Y D J V Q O K
G O F F T H E R E S E R V A T I O N E F
Y K Y Q P R V N Z K C N F V M U C P N R
P C C G F R I S Z P Y J L U L D J G X V
D N T O F Y G P A D D Y W A G O N J J S
A A B J I M M I E S I X H T D D B Y X
```

OPEN THE KIMONO	INDIAN STYLE
FUZZY WUZZY	MUMBO JUMBO
PLANTATION	UPPITY
OFF THE RESERVATION	GYP
ESKIMO	FREEHOLDER
PADDY WAGON	JIMMIES
PEANUT GALLERY	MASTER BEDROOM
	CAKEWALK

33

COINCIDENCE?

I s D e t r o i t r a n k e d t h e
Dn Yzomjdo mvifzy ocz

" B l a c k e s t " c i t y i n t h e
"wgvxfzno" xdot di ocz

U n i t e d S t a t e s b e c a u s e
Pidozy Novozn wzxvpnz

i t ' s a l s o r a n k e d t h e
do'n vgnj mvifzy ocz

m o s t d a n g e r o u s c i t y
hjno yvibzmjpn xdot

o r i s i t t h e o t h e r
jm dn do ocz joczm

w a y a r o u n d ?
rvt vmjpiy?

SHE DID WHAT?

INVENTIONS BY BLACK WOMEN

Have fun with your Google searches.

HAIRBRUSH
HOME SECURITY SYSTEM
CURLING IRON
IRONING BOARD
CENTRAL HEATING
VOICE OVER INTERNET PROTOCOL
PASTRY FORK
FRUIT PRESS
CATARACT TREATMENT
ILLUSION TRANSMITTER

37

CONNECT THE DOTS

Garret Morgam invented a device that makes people of all races angry every day.

A rebus never lies.

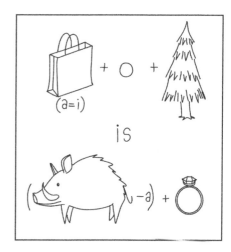

B I G O T R Y I S
B O R I N G

HAIRY CONVERSATION

Help Geneva escape the conversation before Stacy tries to touch her hair.

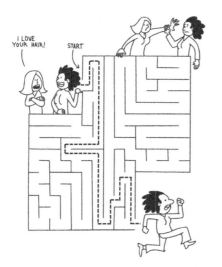

CALM ACROSS CALM DOWN

Guess what some Black people feel they need to do in order to be less scary to white people.

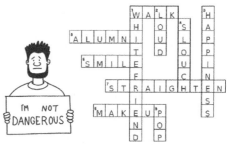

Across
1. When out jogging do this instead of jogging
5. Wear an _____ t-shirt so people know
 you are educated and certainly no danger at all
6. Don't frown
7. _____ your hair so it looks like theirs
8. Wear _____ because people won't think
 you'll beat them if your face is beat

Down
1. Travel with a _____ so people
 know you're safe since you're already vetted
2. Keep quiet and don't be _____
3. Limit the range of emotions you show to _____
4. Don't stand up straight especially if
 you're gigantic
9. If you are in a public place try listening
 to _____ music so they know you're docile

NOT SO SECRET MESSAGE

We know some of
Xf lopx tpnf pg

you are trying
zpv bsf uszjoh.

We appreciate it
Xf bqqsfdjbuf ju.

CONNECT THE DOTS

While researching this book
I found out a Black man named
George Crumb invented what I thought
was a white food.

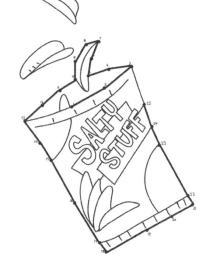

Special Thanks to Lesley Ware, Mary Varnado, Cynthia Varnado,
Lindsay Smith, Philip Gelatt, and Nina Lisandrello

Monumental thanks to the dedicated staff at
Supreme Robot Pictures and Beep Boop Books.

Made in the USA
Las Vegas, NV
16 December 2023

82987975R00037